The Watchdog Exhibition
Woman at Work

VERA MLIA SHERIFF

Copyright © 2017 Vera Mlia Sheriff

All rights reserved.

ISBN: 1548268917
ISBN-13: **978-1548268916**

DEDICATION

To Mary Mlia
A true inspiration. A secretary in the Civil service who raised five children and got them all through University.

Professor Justice Raitt Ngoleka Mlia your soul lives on.

THE WATCHDOG EXHIBITION – WOMAN AT WORK

CONTENTS

	Acknowledgments	i
1	Introduction	1
2	Artist Statement	Pg 5
3	Artist Bio	Pg 6
4	Does a Woman monitor the Society's Ego?	Pg 7
5	Why, How	Pg 8
6	Artworks	Pg 10
7	Bodies of Art	Pg 39
8	Response	Pg 40
9	References	Pg 42

ACKNOWLEDGMENTS

Many thanks and special mention to the teams and individuals who made this exhibition such an exciting journey:
Mr Massa Lemu
Ms Chikondi Chilunga
Ms Marian Chifundo Jumbe
Mrs Happiness Zidana Banda
Mrs Matoga
Mr McDonald Uzziman
Mr Elijah Magona
Umodzi Residents 2009
Fine and Performing Arts Department
The maintenance team of Chancellor College and every individual who contributed or patronized the exhibition..

1 INTRODUCTION

This booklet revolves around a project that was presented in form of an Exhibition and was staged in Studio B of the University of Malawi, Chancellor College from the 25th to 29th October 2010 on the theme: The Place of a Woman as a Monitor of the Ego in a Society. It was staged in the lower as well as the upper gallery by Vera C.J Mlia (now Vera C.J Sheriff) and attracted a great patronage ranging from lecturers, students, medical doctors, sociologists, artists, tourists, and feminists to mention but a few.

Following the intriguing response and curiosity from the patrons on the theme and the artworks, the artist decided to publish a booklet that would aid the understanding of the exhibited pieces. These explanations however should not restrict the audience from reading their own message from the artworks. Each painting found in this booklet was created from the results and examples obtained from a research that the author conducted while preparing for an academic exhibition. Other areas, however, spring from a research that the artist conducted later in preparation for this booklet. A bonus 2018 painting 'The Girl with a Key – Society' carries some of these findings. This section will familiarize the reader with the theme of the Exhibition.

The theme is structured to address two causes. The first is that of showing how a woman monitors the society's ego, and the second is that of exposing the attitude that each individual has towards the subject.

As there are different meanings of the word ego, it is important that a clarification be made on the 'ego' being referred to in this discussion prior to the actual application.

Sigmund Freud's theory of psychology suggests that the psyche (mind) of an individual is categorized into three; the id, the superego, and the ego. https://study.com/academy/lesson/id-ego-and-superego.html. Id is that part of the psyche that harbors instinctual desires that usually aim for immediate and selfish gratification. It accounts for most of the irrational and inconsiderate behaviour in individuals. The superego, on the other hand, is that part of the psyche that seeks moral perfection and strives for, usually, an unrealistic state of utopia. The ego is that part of the psyche that realistically organizes and balances the id and the superego. For an individual to sanely exist, both of the forces, id and superego, have to be active in a balanced state. However the ego does not always manage to keep this ultimate state of balance. Sometimes individuals tilt towards their id and at other times they tilt towards the superego. Mlia's theory, therefore, asserts that women figures in different societies act as watchdogs on the ego of every individual

(males and females alike).

Another important point to be clarified is that of the term woman. Much as this word is ordinarily used synonymously with the word female there is quite a big difference between the two. One can be a female and yet not be a 'woman' just as one can be male but not be a 'man'. The distinctive principle is mere association of certain socially influenced attributes that the word 'woman' carries that are absent in the word 'female'. This is why this project is supported by the theory of Womanism and not feminism per se as most would think. Alice Walker explains it figuratively in the following piece:

1. From womanish. (Opp. of "girlish," i.e. frivolous, irresponsible, not serious.) A black feminist or feminist of color. From the black folk expression of mothers to female children, "you acting womanish," i.e., like a woman. Usually referring to outrageous, audacious, courageous or willful behavior. Wanting to know more and in greater depth than is considered "good" for one. Interested in grown up doings. Acting grown up. Being grown up. Interchangeable with another black folk expression: "You trying to be grown." Responsible. In charge. Serious.

2. Also: A woman who loves other women, sexually and/or nonsexually. Appreciates and prefers women's culture, women's emotional flexibility (values tears as natural counterbalance of laughter), and women's strength. Sometimes loves individual men, sexually and/or nonsexually. Committed to survival and wholeness of entire people, male and female. Not a separatist, except periodically, for health. Traditionally a universalist, as in: "Mama, why are we brown, pink, and yellow, and our cousins are white, beige and black?" Ans. "Well, you know the colored race is just like a flower garden, with every color flower represented." Traditionally capable, as in: "Mama, I'm walking to Canada and I'm taking you and a bunch of other slaves with me." Reply: "It wouldn't be the first time."

3. Loves music. Loves dance. Loves the moon. Loves the Spirit. Loves love and food and roundness. Loves struggle. Loves the Folk. Loves herself. Regardless.

4. Womanist is to feminist as purple is to lavender.
Alice Walker In Search of Our Mothers' Gardens: Womanist Prose (1983)

Womanism accounts for the ways in which women support and empower men and the whole community. It does not get preoccupied with having themselves at the core center of a sexual equality fight where they claim to be equal to men. Having taken note of these very important aspects in this paper we can now proceed to discuss the theme's dimensions.

The first dimension of the theme presents the things that the ego in most individuals struggle to balance. These are the things that society enjoys doing once a dominating woman figure leaves their lives and they immediately stop when she returns. Or, on the contrary, things society does not enjoy doing and stops doing once a woman figure leaves only to faithfully resume the routine when she returns. These trends indicate that the ego tends to tilt towards, for instance, the id. That if the dominating woman figure does not return, the ego may remain in such an imbalanced state.

The second dimension of the theme is that of exposing the attitude that society subconsciously harbors towards the role a woman plays in regards to restricting its id or superego from taking over its life completely. The process that a woman takes society through to teach its ego to maintain the balance does not usually happen without the society's knowledge. We are fully aware and our opinions towards her as she does so each time, turn into thoughts that

dominate our minds. According to J. C. Maxwell (2006), the sum of all our thoughts comprises our overall attitude. Hence whatever response different individuals give towards this subject only reflects whether they appreciate this role a woman plays in their own lives positively or detest it.

The title of this book carries the irony of a dog, which in some countries is considered the society's most despised pet. The dog however has the power to control the society's life by keeping an eye on it and stopping it from trespassing on other people's property or doing things it (society) would have loved to do if the watchdog had not been there.

This book outlines some of the techniques that a woman implores to perform this duty. It also contains some poetry that was exhibited along with the paintings to support the theme.

The poetry was done by two poets namely: Happiness Zidana Banda BAH, and Marian Jumbe MA.

2 ARTIST STATEMENT

My artworks are created to challenge people's thinking with the concept that a woman is a monitor of the ego in a society and attempts to expose the 'real' attitude that people have towards a woman for that role. The concept asserts that at times the ego of individuals tilts towards the Id and, at other times, towards the superego. But for it to maintain an ultimate balance there is need for a woman to act as its watchdog and observe it's progress. She makes sure individuals are neither too selfish nor too selfless in their interaction with life and fellow individuals.

The art creation concentrates on the role of 'woman' and not that of 'female'. My exposure to the terms 'Feminism', and 'Womanism' led me to the realization that one can be female and yet not be a woman. These females, therefore, are part of the society just as males and men and together they rely on a woman to keep their ego in check.

I do not vie for the status of women and men as equals but as two different figures with different important roles in the society that have to be equally respected and recognized. (Alice Walker). My influence comes in two correlating contexts. First, the subject-matter, followed by presentation.

The content is rooted in the theory of Womanism and the ideas are derived from a woman's everyday life from diverse backgrounds and traditions- activities that empower, save, serve, and support the whole community. In terms of presentation, I am influenced by a lot of expressionism, narrative art, pop art, abstraction, and collage, to mention but a few. All these are used to manifest the subject-matter each with its characteristic trait.

According to my style of painting or creating artworks, I dominate my frame of composition with a woman, a feature, symbol or anything that is associated with a woman. In the frame, she is given somewhat dominion over things that the ego in many an individual struggles to control.

I also take advantage of the choice of material in the creation of the artworks. Some artworks are created using various media to add to their intended meaning. For instance, carton, which is very fragile, can easily be set ablaze and be defeated yet it looks perfectly composed and does not yield to such threats of reality. A box can house metal and wooden accessories and give them a neat and organized look. I equate this to the 'weaker sex' notion. That is to say much as women are considered as the 'weaker sex' they are in real sense the backbone of the society. Another media that was used in the exhibition was a jagged wooden board to physically present the ability of a woman to hurt those who are not careful in handling or dealing with her. This is to mention but a few. All these metonyms are influenced by the subject matter and incorporated into the artworks as things that most laymen could miss in the appreciation of the individual artworks yet they will always contribute to scholar projects dealing with critical analysis and origin of the works.

All in all, my work aims at reflecting the concept that a woman keeps the ego in check in societies and that the treatment she gets is as a result of the same.

3 ARTIST BIO

Vera Mlia Sheriff is a Malawian artist and art historian with a Womanist influence. Her academic work aims at challenging people's thinking with the concept that a woman acts as a monitor of the ego in a society and exposes the subconscious attitude that people have towards a woman for that role. Her work does not fight for the status of men and women as equals but as two different figures with different important roles in the society that have to be equally respected and recognized.

Mlia Sheriff does not restrict her work to her academic theory, she explores art and various art movements on a wide array of themes like culture preservation and human rights activism. Her main medium over the years has been oils. Recently she has advanced into digital art media. Mlia Sheriff is also a singer and author.

She holds a BA in Fine Art and studied under Massa Lemu, Peter Goff, and Richard Mwale. She worked for a local bank for 4 years before resigning to pursue her art dream. She owns Studio4humanity an illustration and animation social enterprise. She is a Young African Leaders Initiative (YALI) Fellow.

4 DOES A WOMAN MONITOR THE SOCIETY'S EGO?

To monitor is to watch and check something over a period of time in order to see how it develops, so that one can make any necessary changes. (Oxford Advanced Learner's Dictionary 7th ed. Oxford University press. UK). This rules out all misconceptions that whatever is being checked on has no control or ability to control itself. It but assumes that the power to control is to a limit further of which another force has to be applied to complete the task.

Individuals in different societies have the ability to control themselves. Their ego strives to strike a balance between the id and the superego. But one would wonder where the ego obtains its raw materials to use upon carrying out the task. Id, superego, and ego, all three are instinctually oriented. However, it takes a sociological influence to grow them or depress them. This is the first point where a woman comes in to perform her duties. A woman spends her time uploading moral and any other relevant values into the growing psyche of a young individual until they become part and parcel with him or her such that the ego applies these values later in life whenever a situation arises that requires sane judgment.

A second point where she comes in is when the individual's value acquisition has been achieved but the individual has encountered a new or strong challenge which has confused the ego. Instances such as job loss, failure, loss of a loved one, risk-gone-bad among others. In this state the ego malfunctions and loses that power to balance the id's demands or the superego's demands. It is at this time that it tilts towards one of the two. In a situation like this, woman steps in to enforce the values that the malfunctioning ego has lost track of and helps to boost it back to the level where the individual is human enough to live with. Affluences of this malfunctioning may not necessarily be limited to negative cognitive disturbance but also to a new status that presents the subject a feeling of overall authority or supremacy. A high leadership position, a raise in social status, success, or fame to cite a few.

5 WHY, HOW

WHY DOES A WOMAN MONITOR THE SOCIETY'S EGO?

Because of her own id

A woman usually controls unpleasant behavior around her to save her own face in the society. She does not delight in the shame that will be painted on her name and family therefore she makes sure it never comes. As she laughs at other families she keeps her fingers crossed that she never ends up on the discussion board because of her husband, children or relatives. This selfish thinking makes her go home and make sure all is under control then shows off her subjects as the perfect model.

WHAT TECHNIQUES DOES A WOMAN USE TO MONITOR THE SOCIETY'S EGO?

Her superego

Woman employs her own desire for an unrealistically perfect state of being to raise the bar for which the society is to aim for. At the back of her mind she knows the society cannot achieve it but the trying will lead to a desirable result. She employs both physical and psychological techniques as follows:

1. Her position in regards to basic needs

Woman uses this to threaten or punish her subjects if they do not comply with her demands. In most societies she is in charge of food preparations, in some societies she is even the bread winner. In some societies she is the one who locks the doors when retiring for the night. In cases where she is not the breadwinner she is usually the closest influence to the decisions of the breadwinner. This is to mention but a few scenarios but in a nutshell woman assumes a powerful position in the availability of comfort and survival in most societies as such she knows no one would want to get in bad books with her.

2. Her reliance on religion

Here, woman uses religious dos and don'ts which usually happen to be in line with social values and expectations. She makes sure she introduces religion to her subjects at a very young age such that it is part of them as they grow. At

a ripe age she does not need to threaten the subjects with physical punishment as she simply reminds them that they are committing a sin which is punishable by the particular divine being or deity they pray to. This divine being in many cases is omnipresent to ensure this threat continues to work even where she is not available. Upon hearing this, the subjects either quit whatever they were doing if they are loyal or if they continue they do so as sheer rebels to their faith.

3. Her reliance on humane values

These are the instinctual values that every individual, who is considered to be sane, possesses.

4. Her reliance on culture

These are the values that the particular grouping of people that the individual is growing up in or belonging to follows and observes. The guidelines are imparted to the individual and if the individual behaves contrary to that then the individual is betraying the entire grouping.

Woman's responsibility is not a jolly ride. It is just as fragile and volatile as the same ego of the society that she yearns to oversee. It is as complex as the plight Nnu Ego faces in the Joys of Motherhood.(Emecheta B, 1979). She has to protect the love Nnaife has for her yet cultural duty binds him to adopt his late brother's wives. Nnaife's own pleasure of this obligation places on Nnu Ego a ten times heavier burden of taming her own ego before she can assume the role of watching that of the people around her.

6 ARTWORKS

 This segment presents the artworks and a few faces of their interpretation. Just like any artwork, viewers are at liberty to read their own story from these pieces. I urge viewers to appreciate the art before reading the stories behind them. Art is a psychological way of expressing deep thoughts as such there could more meanings unknown to even the artist.

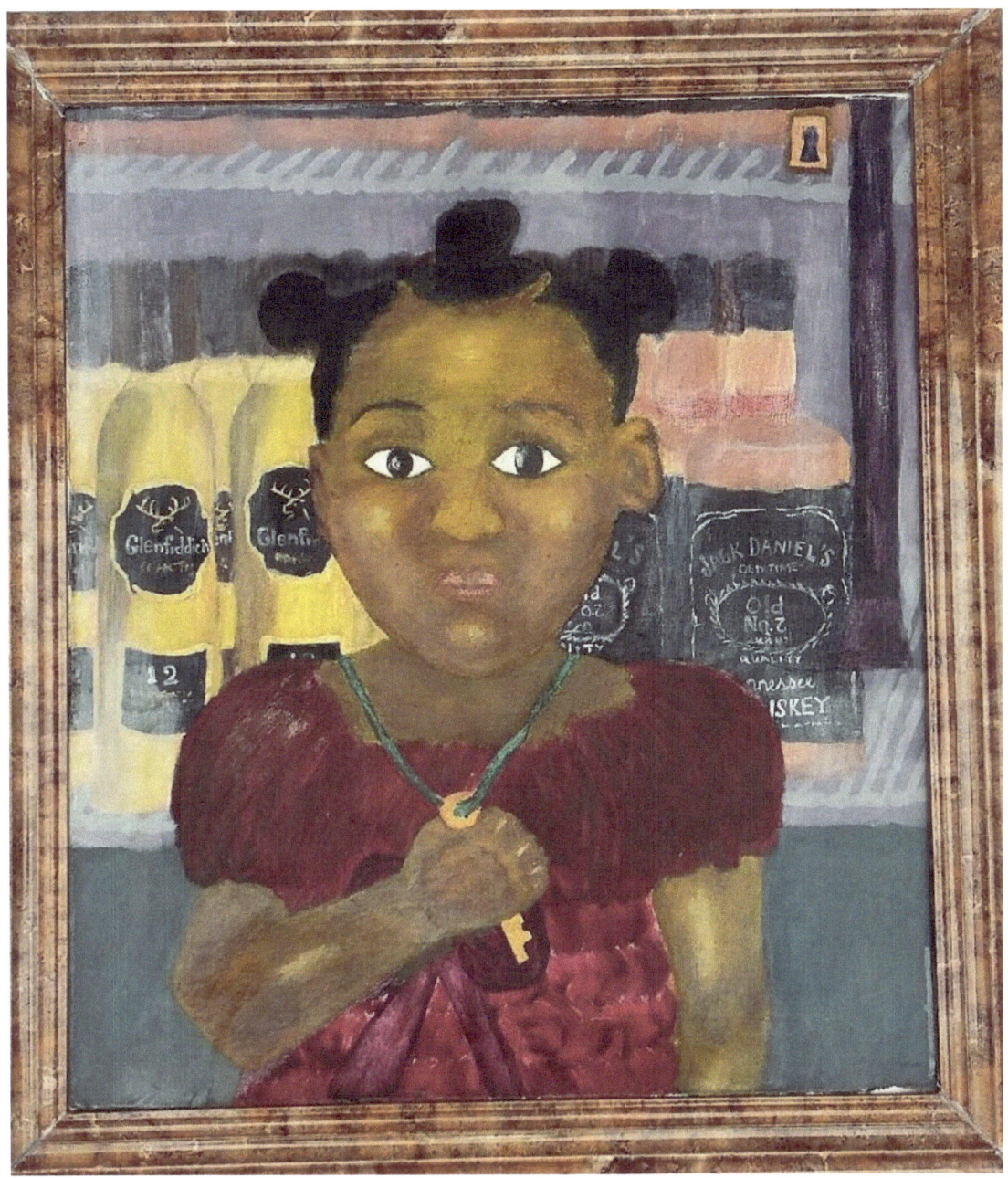

The girl with a key. Oil on Canvas. 2010.

- A satire on how the 'weaker sex' controls the society's desires.
- Its dimensions are 22.8x26.7inches

The project's research revealed that eight out of every ten individuals who go to drinking places such as bars, pubs, and clubs, to mention but a few, go back home much earlier than they would have loved to because of a dominant woman figure in their lives. The cited woman figures were: a mother, an aunt, an elder sister or wife.

The young girl standing in the painting holding the key is, therefore, but a mere illusion. She presents the concept that the premium bottles have been locked up and she is holding the key to that store place. That whoever wants to get through to obtaining the bottles has to first negotiate terms with her as she is aware that she is holding an important and a crucial deciding factor, a key.

The reason behind placing a young girl instead of a fierce looking 'iron lady' is simply to satirize the notion of the 'weaker sex' branding of woman. It is to mock the society that the one that is considered to be weak holds the key to their freedom and their wildest forms of happiness. They could easily overpower her physically if they wished to yet they still respect and play along to her tune. The following is an exhibited poem written in 2010. These poems were intended for guests who had no chance to interact with the artist to get first hand explanation to each and every artwork as such they were coined in a very straight forward fashion. Nevertheless they are presented in this book to allow the reader have the same experience as those who attended the exhibition.

KEY TO FREEDOM
Marian Chifundo Jumbe

"Barman, uwiri" (Barman, bring two)
The first bottle goes down, then the second
"Barman uwiri…." The numbers keep increasing
…Four, five… he soon loses count, starts seeing doubles
To stop at this point is a question of courage and love of neighbor
Some will drink their heads down; others save for tomorrow's round
Still most think of those they've left back home

The 'weaker sex' of society

She is weak on the outside, but has the power to control things
Easily overpowered: a slap on the face, words that sting her the most
But when she holds the key, you are seriously locked out
Your freedom becomes limited; you may wish she was inexistent
But you have little choice, leave the bottles and get back to 'mummy' or to 'wife and children'
If you still want to socialize next time and the next, and the next…

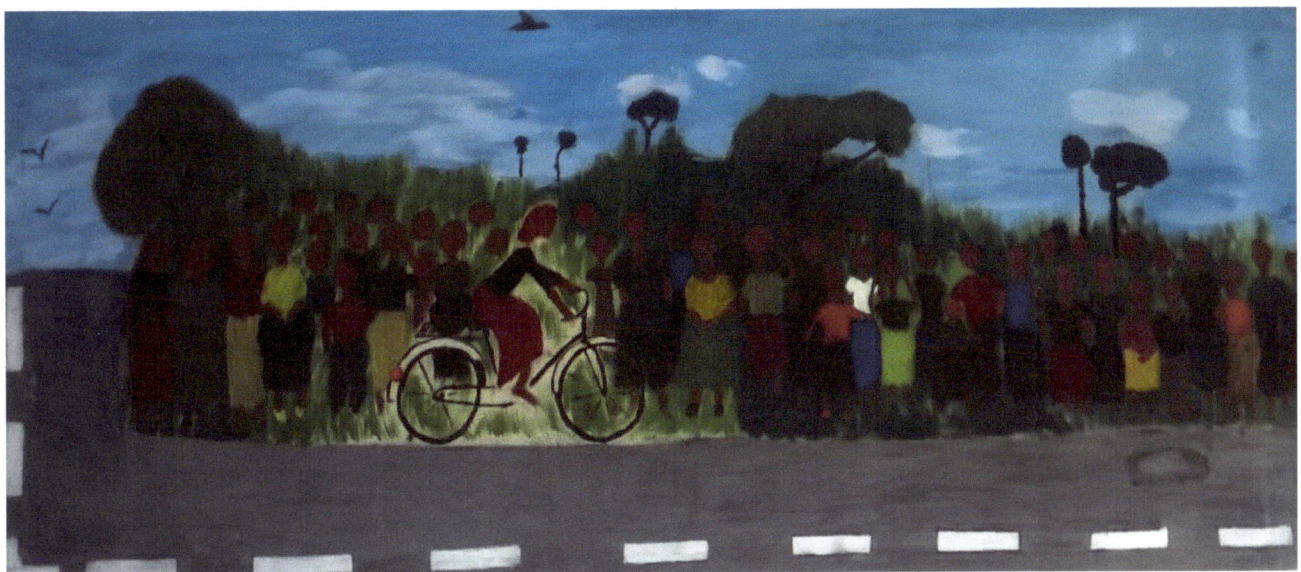

The African runway. Oil on canvas, 2010

- An assertion that women's gossiping controls the fashion trends picked by the society.
- Its dimensions are 35.8x14"

Just as models cat-walking the runway to showcase the newest trends in the world of fashion have critics, so do the models parading on the African runway. Only in this case, the runway is the road, marketplace, church and other circles that everyone passes through.

According to this research, nine out of ten youths find it hard and uncomfortable to pass by a group of women when they are wearing clothes that they know are not in line with the society's expectations. They will usually change route, go back, or pass with their insides tied into a knot as they claim they become the topic of discussion. In some societies not only them but even their families become the subject matter. Women, therefore, help in keeping watch of the dress codes, and physical outlook as well as behaviors that the society's ego has failed to check on its own.

<div style="text-align: center;">

THE FASHION POLICE
Marian Chifundo Jumbe
Where they are gathered
Sharing house and garden tips while passing away time
Learning or practicing the latest recipe
Or some with a knitting in their hand

</div>

They share stories happening in the neighborhood, gossiping sometimes
Their laughter rings out, the echoes reaching the next village
There no female passes by wearing a jaw-dropping tight, drooling short dress
Or a male with a hairstyle of his own...
All that passes is certified

THE WATCHDOG EXHIBITION – WOMAN AT WORK

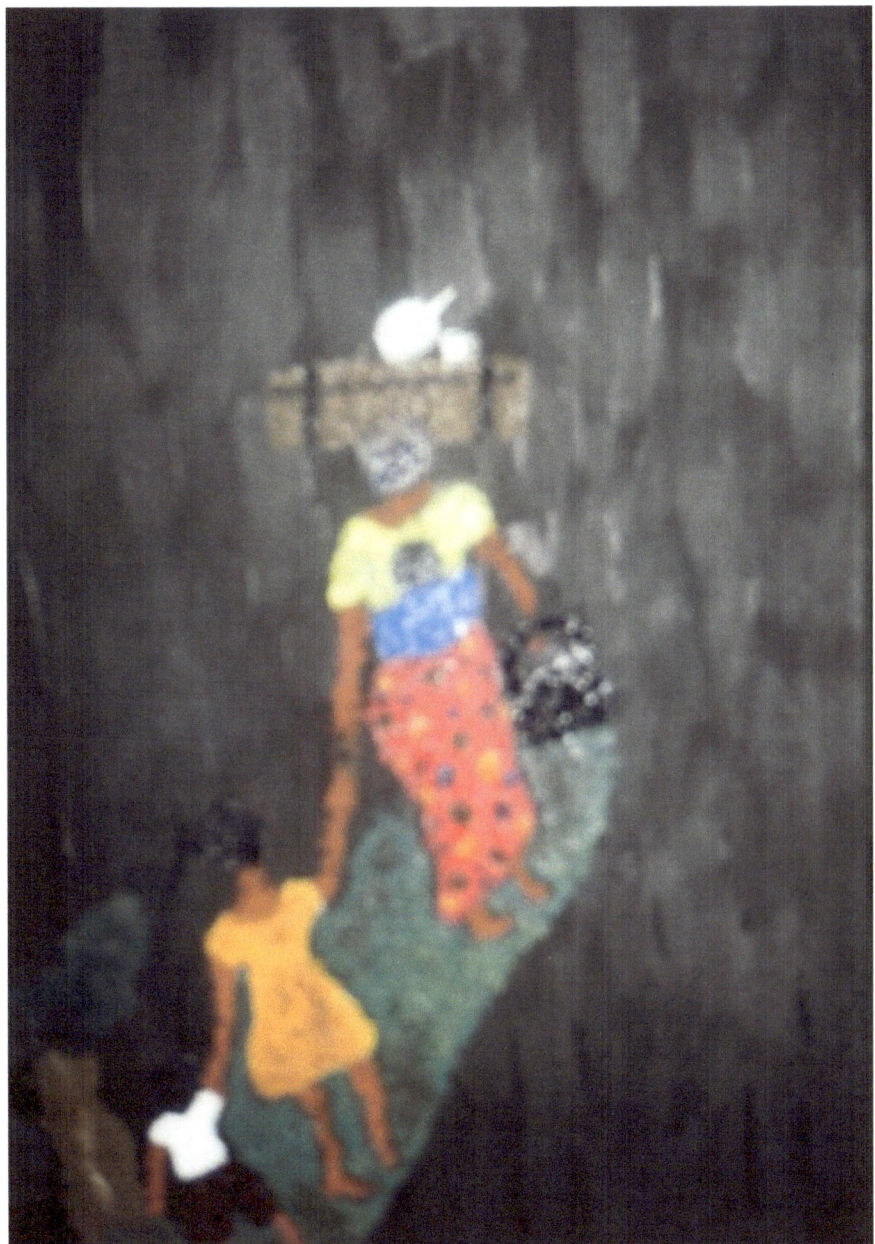

When enough is finally ENOUGH. Oil on canvas, 2010

- A depiction of one of the techniques a woman uses to eliminate some habits in her husband's life.
- Its dimensions are 12x24"

Women are said to use threats to change the people around them just as any law making body relies on a law enforcing body to stamp their laws. Much as the threats keep coming in form of nagging, a woman is said to take time before she actually carries out her threats. Many a woman will not leave, for instance her husband, the first time she says she will pack up and go. She is said to expect him to change the habit that is bringing the tension in their relationship and in the mean time she perseveres. seven out of ten divorced women claim to have warned their husbands more than once that if a certain behaviour continued they would walk out of the relationship. In the case of the above painting, woman keeps bearing and raising children until she finally carries out her threat. Things have really gone beyond verbal warning and she has to act. If he still wants her he has to take tangible steps towards the desired change, thereby according the woman victory as the person responsible for curbing the behaviour.

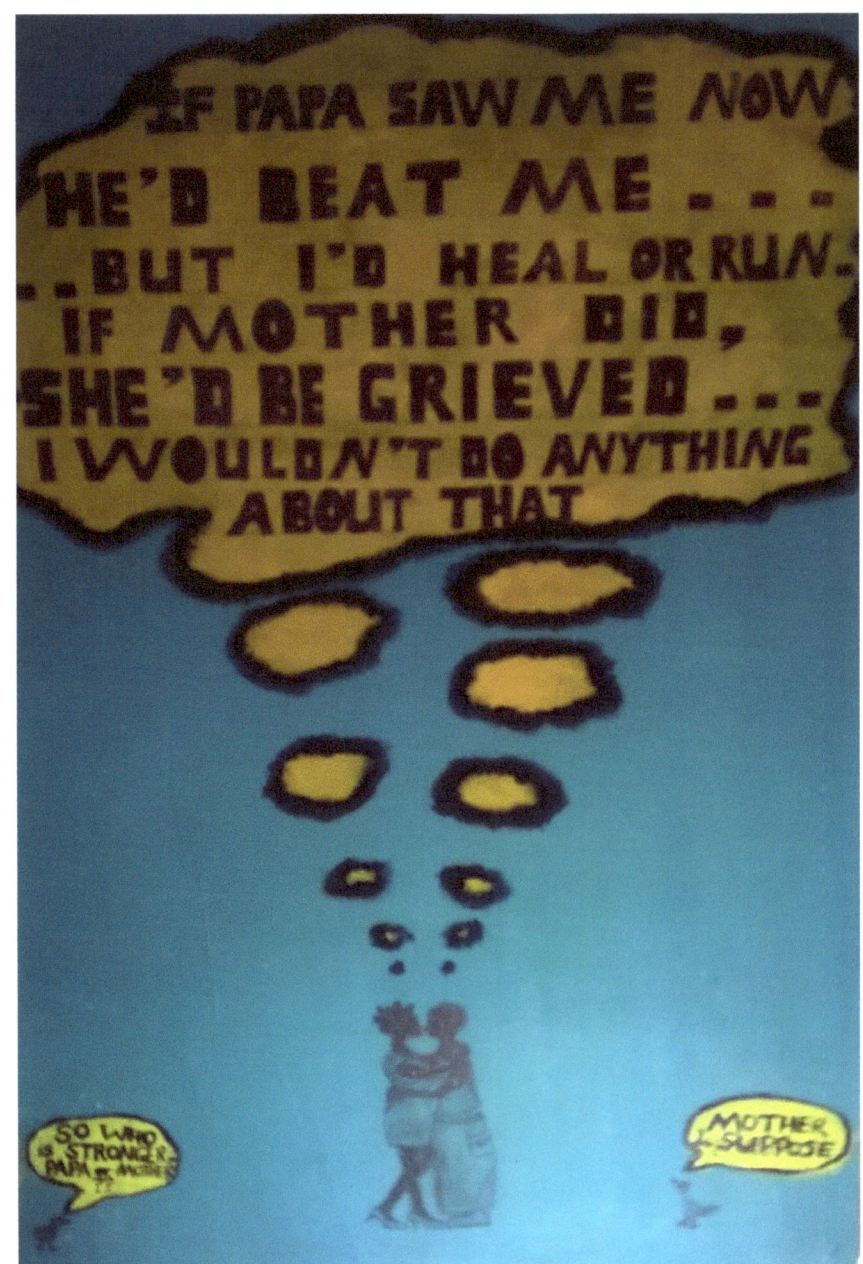

If mother saw me now. Oil on canvas. 2010.

-An assertion that women use emotional strength which is more effective than brutal strength.
- Its dimensions are 14x24"

The painting reads,
"IF PAPA SAW ME NOW, HE WOULD BEAT ME... BUT I WOULD HEAL OR RUN. IF MOTHER DID, SHE WOULD BE GRIEVED... I WOULDN'T DO ANYTHING ABOUT THAT" A spectator asks, "SO WHO IS STRONGER, MOTHER OR PAPA?" Another spectator responds by saying, "MOTHER, I SUPPOSE"

Seven out of ten individuals claim to desist from certain behaviours for the fear of disappointing dominant woman figures around them than the remaining three that hold back because of other factors. In a setting of a father and a mother, it is argued that it is the father who uses brutal strength to punish or bring discipline. The mother is said to give benefit of doubt because of the trust she has in the offending individual. Because of this gullibility she tends to keep backing the individual up and persuading the father that the individual is not as bad or as evil as he thinks. This makes it harder for the individual to let the mother down as compared to the physical pain which will heal sooner or later and which the individual can run away from if given a chance.

MAMA'S VOICE
Happiness Zidana Banda

She likes talking in whispers
That I should hear one word at a time
Her voice is smooth

Caressing my solid heart of stubbornness
All to uphold my sanity

Mama's voice is loud
When she talks
The frames hanging on the wall shake
Her heart is weeping
Her soul in turmoil
Wishing my life would be colorful

Mama's voice is sweet
She tells me I can go on
And walk through the tiny road to my fortune

The creator's voice comes out of mama
Her mouth is a vessel
Through which he whispers to my soul
Salience, you are my mama's voice

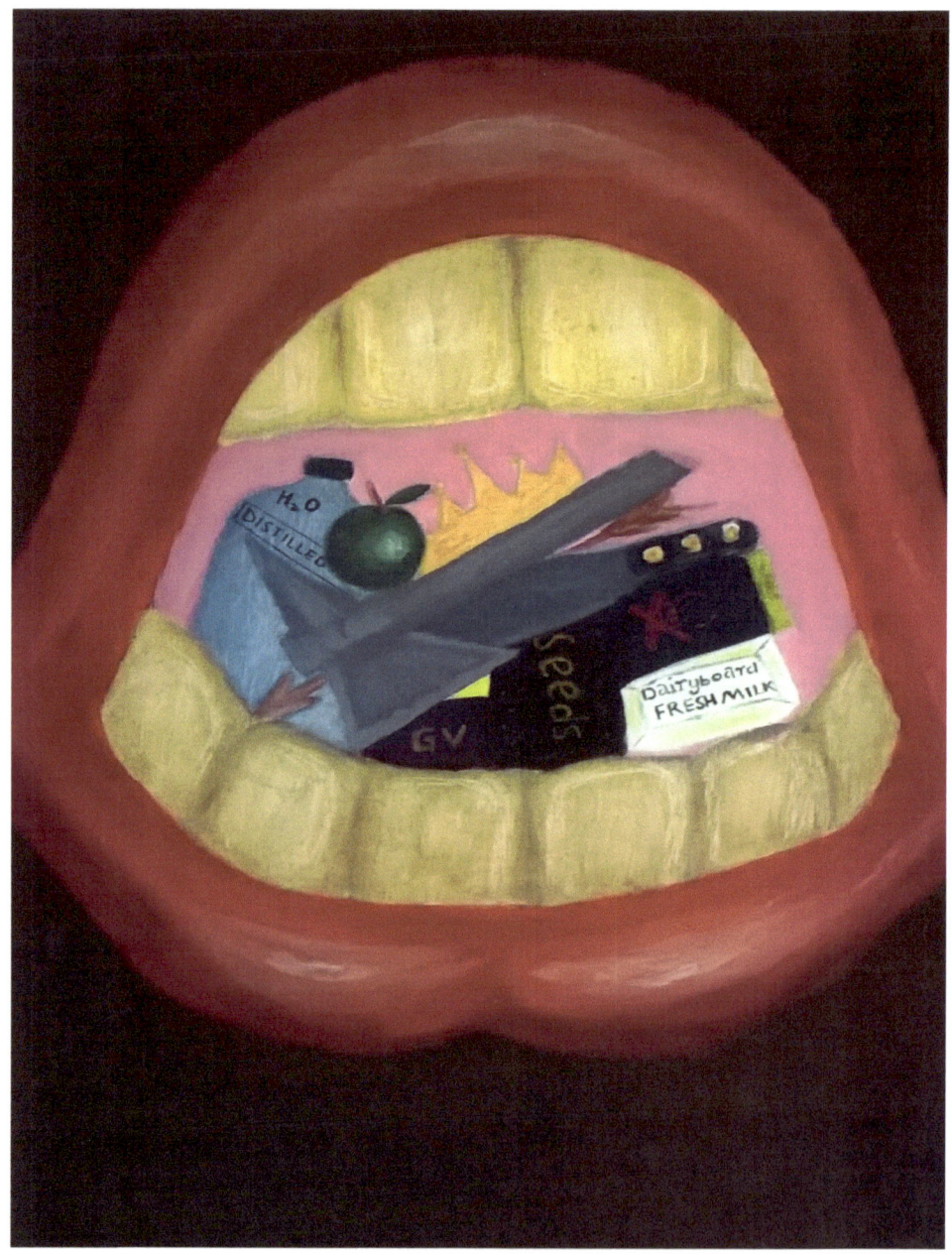

Mouth of a woman. Oil on canvas, 2010.

- An assertion that the mouth of a woman is considered to be rotten
- Its dimensions are 18x27"

Six out ten people in his research believe that one of the reasons women are abused in different ways is because of their mouth. That is, people consider women to be nosy, naggers and kill-joys in a society. But after critically analyzing the reasons that people give to justify their attitude towards the mouth of a woman, one can argue that it is because a woman uses her loud mouth her as her implementing tool charged with emotions to curb behaviors that she thinks are not healthy for the society.

She destroys bad behaviors and encourages good ones that the society gets busy trying to get rid of because they do not seem interesting at that moment but the woman believes will be to its own good later in the future.

SOCIETY'S TREASURE
Marian Chifundo Jumbe

"Even so little… the tongue boasts great things…"
Placed within the mouth, the Creator knew better
For if inside it still kindles fire… put it on the ground and you can imagine the rest

What the heart is full of, the mouth does really say
Out of the mouth comes encouragement and things that put others off
It builds and destroys, plants the seeds and uproots the weeds
Waters the seeds, nourishes, nurtures and brings them to maturity
Rotten though it be, it sustains the growth of society
And stands for those who are too weak at the knees

A double-edged sword with the ability to wound or kill
From within come words that heal and smooth the ruffled feathers
Picks society's bad habits before they are too ripe and mature for correction
It socializes, rebukes, tirelessly works for the good of the whole
When the cat is away, the mice do play

The mouth of a woman utters self-glorification
Acts bossy when the need arise
The venom that comes of it, worse than mamba's
Later brings in the mammalian food-for-young to purge the system
All this is because the upbringing of society's leaders lies with this treasure

VERA MLIA SHERIFF

WOMAN, DID HE TELL YOU?

Happiness Zidana Banda

That he esteems your loyalty

Which the majority

Mistakes for mediocrity

Your confidence is always under his admiration
Rendering patience in the state of contortion.

Woman did they tell you

That life is sweeter for you are there

That you brighten dark hearts

Your gentle soul

Amending their characters

Deep within them

They uphold you with high regards

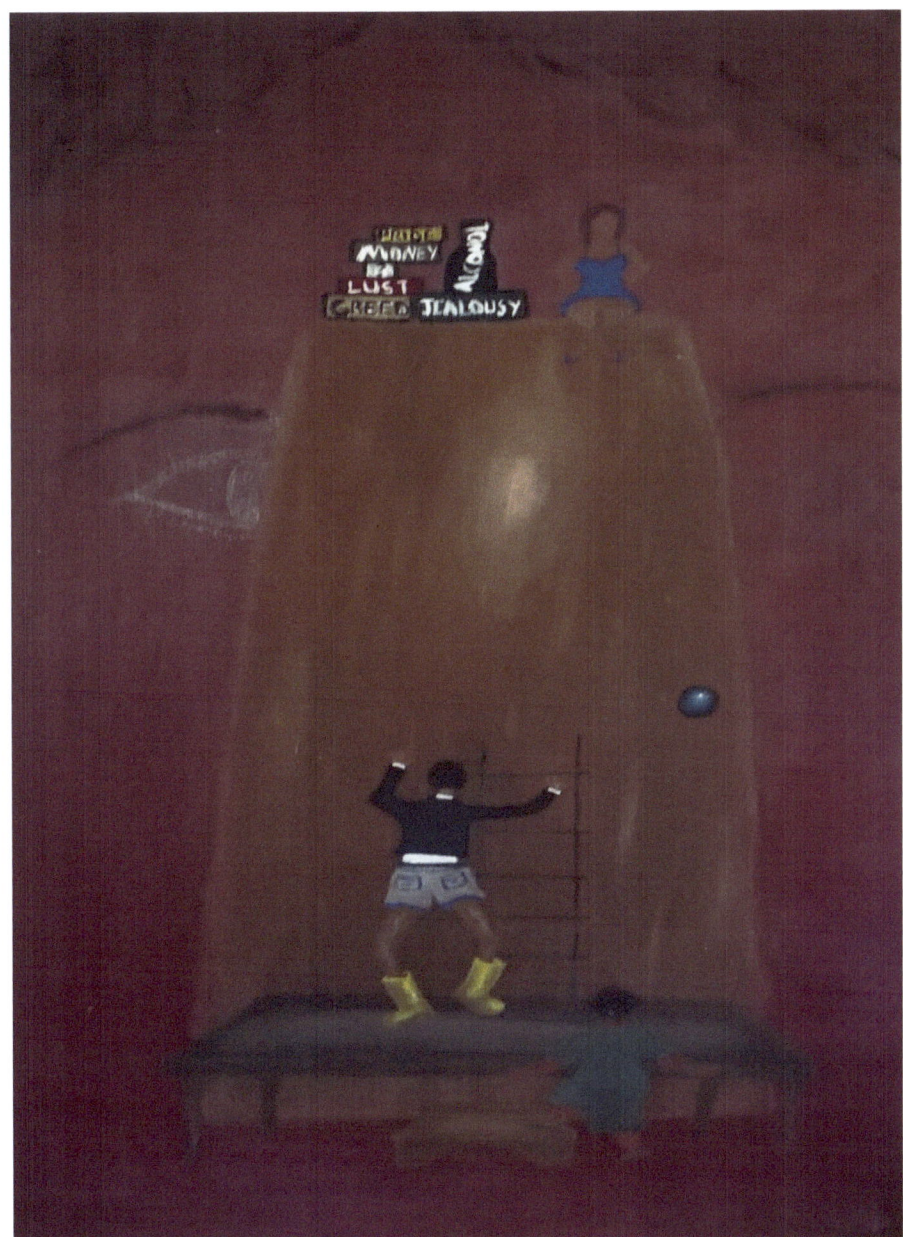

The Drive. Oil on canvas, 2010

-An assertion of a woman as tolerant so long as one has achieved greatness in life.
-Its dimensions are 17x34"

Seven of out ten married women in this study claimed to tolerate certain behaviour in their spouses' as long as the spouse is putting food on the table and giving them the best lifestyle. This mentally is said to apply even on child-mother relationships, and other members of the society who have reached a certain level of greatness. This subtly gives the society motivation to work extra hard in life in order to impress woman and get away with certain pleasures that if one was a good-for-nothing would not have gotten away with.

In the artwork this is presented as a man who has to go to beyond every hustle to reach the top. Deep down he knows that he does not only want the things the woman supporting him wants. He wants even the wild desires. And she is aware of that, however, she will still support and open the door for him so long as he first gets to the required level of success.

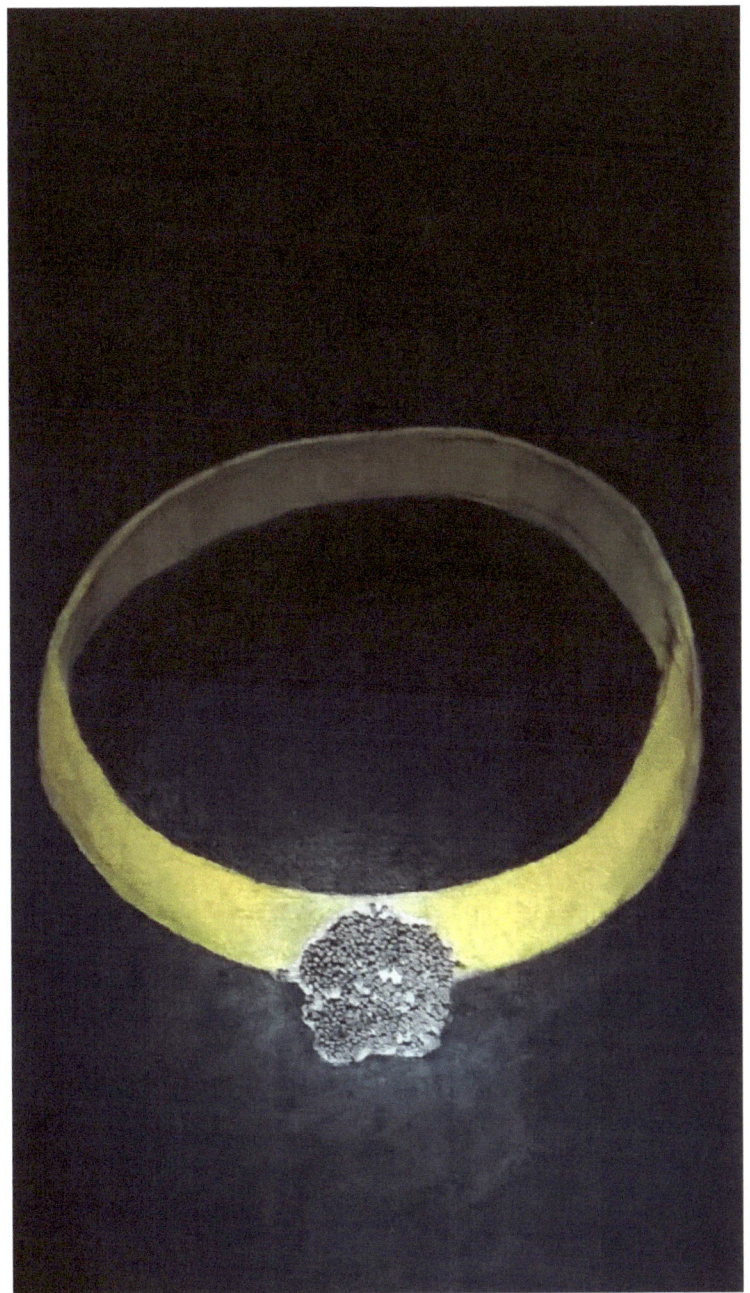

Her ring. Oil & beads on canvas, 2010

-A portrayal of women's sexual efforts to make marriages work.
-Its dimensions are 12x24"

To begin with, the painting has beads glued to where a precious stone would have been. The content captures some of the efforts made by the 21st century African woman to keep her husband from promiscuity. This stems from sheer curiosity that traditional females are better than the uptown girls like his wife as they still follow what they were taught in the village in regards to satisfying a man. Initially, she had been preoccupied with other cultures and ignored her own and when she realised that her husband was following local girls she tries to go back to her roots and satisfy her husband's curiosity herself. Women in many societies are given the responsible of being attractive to their husbands even if the male has let himself turn into a pig years after marriage. Even before marriage, a woman will go through different counsel and rituals to prepare her for the male while the male is busy celebrating his last bachelor days. Some rituals will physically change the woman forever. It is for this reason that the exhibition has eleven artworks as a dedication to all women who have had their labia transformed to satisfy males. The burden of her husband's fidelity is ironically placed upon woman herself.

BEADS FOR QUARTZ

Marian Chifundo Jumbe
Every lady yearns for it
Something to show off
For its possession is a symbol of chastity, abstinence and faithfulness
But if you look beyond that which you see and choose to open wide your eyes
Then will you appreciate the hidden meaning behind the latest ring

A traditional wedding band around the third finger of the left hand
Is as good as a 20-carat gold ring, or a diamond one adorned with quartz
For both symbolize the same thing: a proper wedding to the spouse you live with
Cohabitation and sleeping around is not condoned, especially among the lady species
For the ring has no beginning or end, it encircles those inside it

She got what she wanted: a colorful wedding, white veil, and an 8-carat gold wedding ring
A year went by, two or more perhaps and believed it was her own 'happily-ever-after'
Eventually she got the shock of her life, neighbors backbiting, and pointing fingers at her
"Amwali kodi mwamva? Amuna awo a nebatu akugona ndi wantchito, dzana awagwira ndi message yochokera kwa chibwenzi…" (Have you heard? Her husband is sleeping with their maid; two days ago he was also caught with a letter from another lady)
"Where have I gone wrong, what was I told that I did not do right for my husband?" she lamented

Similar cases reportedly happened to some of their neighborhood, and others of the villages nearby
By and large they grasped what had gone wrong, and worked out a way:
Quartz and gold are but a western concept, a means of dissolving the African culture
Our ancestors knew only beads, small hard with a hole through it
Bridal showers urge their use to divert the husband's mind from roaming outside the 'latest ring'

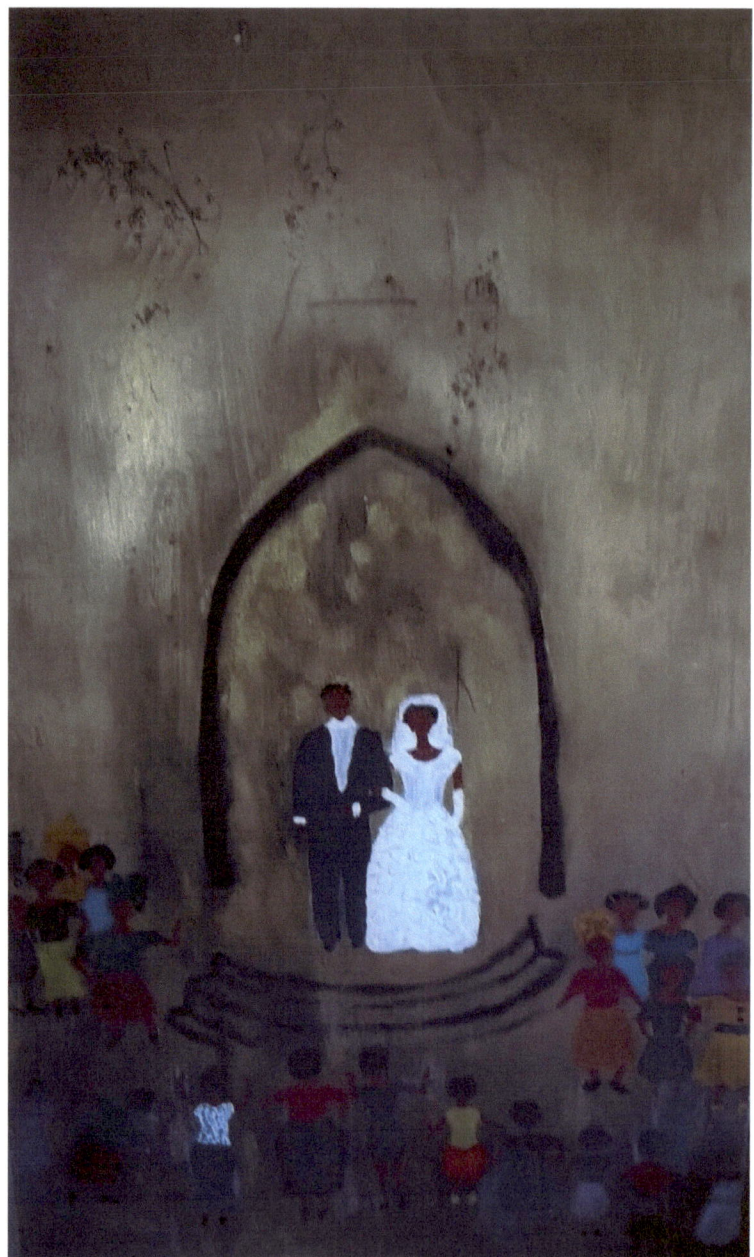

The wedding. Oil & beads on canvas, 2010

-A proposition that women encourage marriage so that the society can satisfy its pleasures and desires in a confined and responsible way.

-Its dimensions are17x35.8"

Of all the different social groupings that took part in this project it was unanimously agreed that women are the force that propagates marriage and weddings the most. It was claimed that women impose the rule that it is not right for one to have sex with a person who is not his or her marital partner. In essence, one should live with and have sex with one person for his or her entire life and after making full unconditional commitment. And that no matter what problems they face they have to stick to the vows and not part ways. This kind of thinking put into practice means an end to all premarital as well as extramarital affairs. Wherever a woman is involved, she will encourage marriage for all sexually active citizens (as long as circumstances allow them to) and she will not buy any excuse for not doing so if the citizens are quenching their desires outside marriage.

The painting presents only women at a wedding just to capitalize the concept.

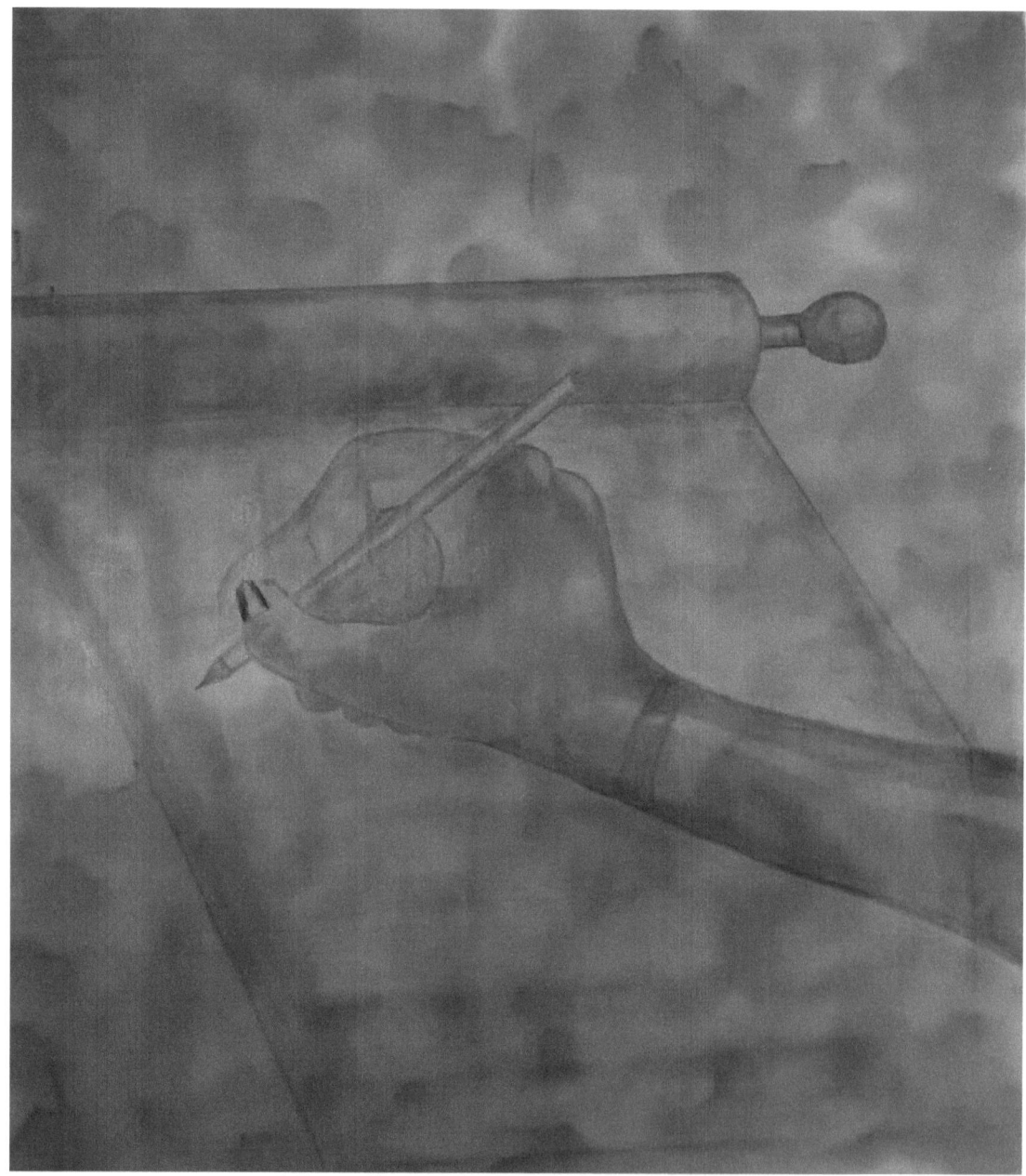

A Recording Forgiver. Pencil on canvas, 2010

-A representation of a woman as someone who keeps old records and keeps updating them.

-Its dimensions are 22.8x26.7"

Nine out of ten individuals in this study claimed that women are gullible and flexible to offence and forgive easier than males and females. It was noted, however, that women keep record of almost each and every wrong they forgive. That it takes forever for them to forget that someone once offended them and that they reacted better than most would have.

This element is said to scare off further offences by those around her knowing that once they offend her again she will bring out and remind them of all the wrongs they have done to her in the past with (usually) exact dates and occasions and show them how untrustworthy they are.

This depiction of a lady's hand writing on a scroll symbolizes the age-old presence of her track of records.

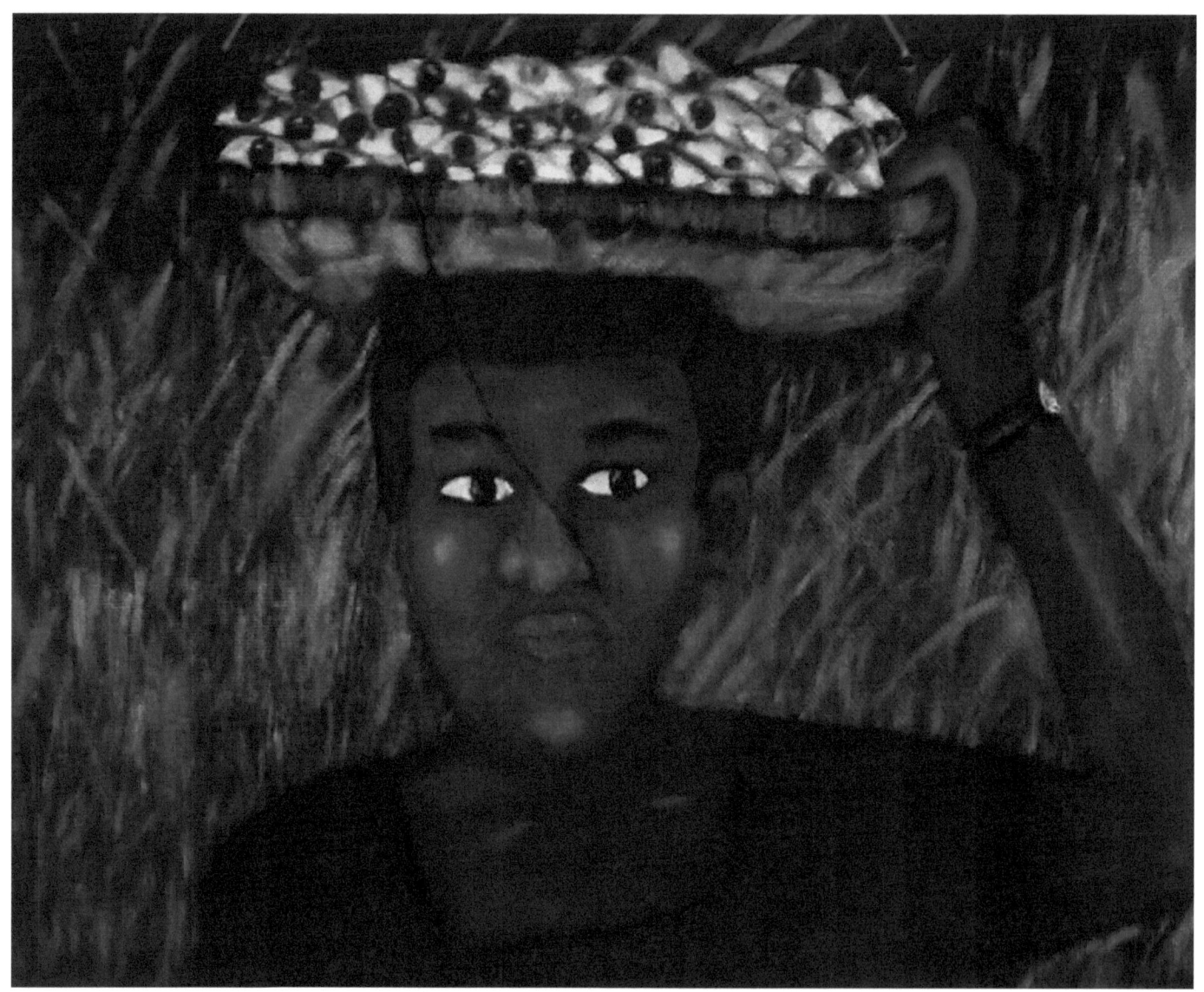

Here comes sight. Oil on board, 2010

- A proposition that a woman is the one who brings knowledge of moral values, insight, understanding and all the functions of the eye, to a society.
- Its dimensions are 18x24"

Six out of ten individuals in this study alluded their good qualities to woman figures in their lives. That it is a general principle that what children become when they grow up is a great percentage of the woman who raised them, and smaller percentages of people around them and the rest is what they themselves want to be. The woman can teach good values or bad values but the most important factor about this point is that a woman brings the eyes for which individuals use to look at life.

This artwork was done on a board behind which the artist's mother had a printed alphabet. At a young age, she would make the artist sit in front of this board to do her homework. The artist used to hate this spot and so would stick bubble gum and stickers on it, she even broke the board one time. The artist therefore decided to use this same board to create the artwork of the above theme to show that the society mostly detest woman's efforts to make it better people although it is for their own good.

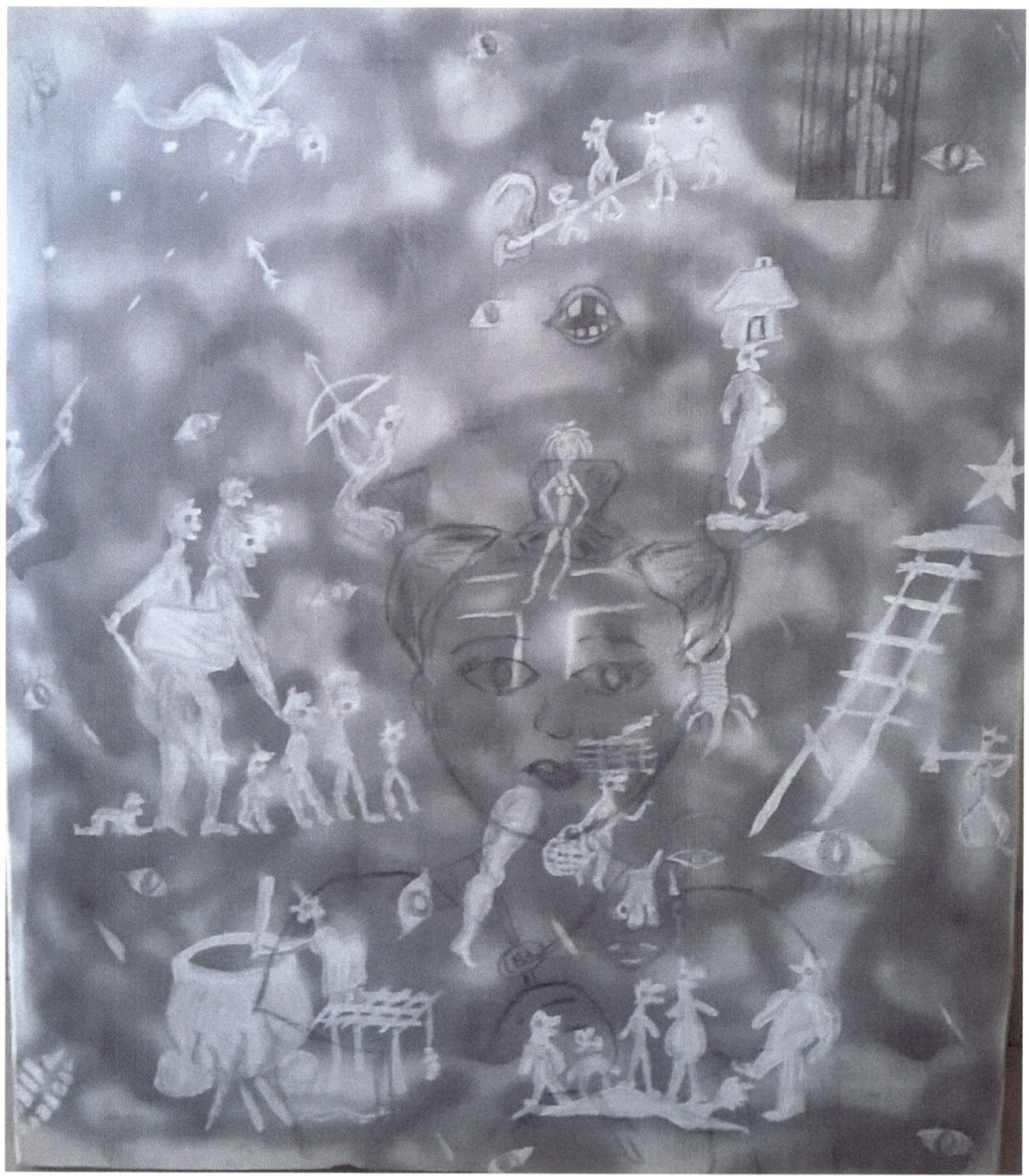

The Girl with a Key -Pink Guernica. Pencil and acrylic on canvas, 2010

- An abstract representation of the emotions surrounding concept of 'woman'.
- Its dimensions are 22.8x26.7"

The first Guernica painting was created by Pablo Picasso in 1937 in response to the bombing of Guernica Basque country by German and Italian warplanes on 26 April 1937 during the Spanish civil war. www.pablopicasso.org/guernica.jsp. Following a commission by the Spanish Republican Government Picasso created a large mural for the Spanish display at the Paris International Exposition in the 1937 World's fair in Paris. The emotional painting captured the tragedies of war and the suffering, pain, and agony inflicted upon individuals, particularly innocent civilians.

South African Dumile Feni created the African Guernica in 1967 and it is considered to be the second 'guernica' in existence. It captured the ills of racial disparities and neo-colonialism among other themes.

The Girl with a Key- Pink Guernica comes with intentions as those of its predecessors', capturing the indescribable agony of some innocent civilians. Only in this case it focuses on a Woman. The war between the sexes which is fought by males versus females usually heaps all the consequences on a poor woman who does not believe in power equality at all. Research has shown that many times women's performances are judged on a gender scale. For instance, a woman competing for a position and has a record of excellent performance will get comments like, "She is knowledgeable and bright, she performs like a man" and for a male with poor qualities, "He is slow and stupid, he performs like a woman" instead of merely judging the individual's behaviour.

Just like the predecessors, Pink Guernica shows gruesome faces and images to bring in the emotional element, and a few depictions of how she suffers. For instance, one is shown flying with wings and being shot down from all angles. This represents the frustration and discouragement women face in our societies as they try to achieve things that no other person has managed to achieve. A presentation of a ladder with the bottom steps cut off also depicts the same notion. There is another presentation of a woman with so many children relying on her to lead them and a fully grown man riding her back carrying a rod in his hand. This illustrates how a woman tirelessly takes care of the family only to be abused and ill-treated instead of being appreciated. Much as it is considered as the role of a woman to care for her family, it would be expected that the people around her appreciate her work. Instead the beneficiaries use these privileges abusively. Another depiction is the pressure to do things that are beyond her capacity and dangerous which is represented as a woman standing on a plank stand to reach and cook from an oversize pot with a snake coming out the firewood she is using; and finally an image of an extremely thin model on a runway which represents the pressure that is constantly exerted on women in order to look beautiful and sexually appealing. All these pressures are expected of any individual who assumes the role of a woman even if she is young in terms of age. The painting has many other images but discussed were the most inquired.

<div align="center">

DESPISED VOICES
Happiness Zidana Banda
Our words are countless
All meandering in the state helpless
We cry aloud helpless

</div>

VERA MLIA SHERIFF

Perhaps you might hear our cry endless

Multitudes deem us fruitless
Labeling our heavy duties effortless
And eat on top of our heads thoughtless
But we are creatures not aimless

BONUS ARTWORK

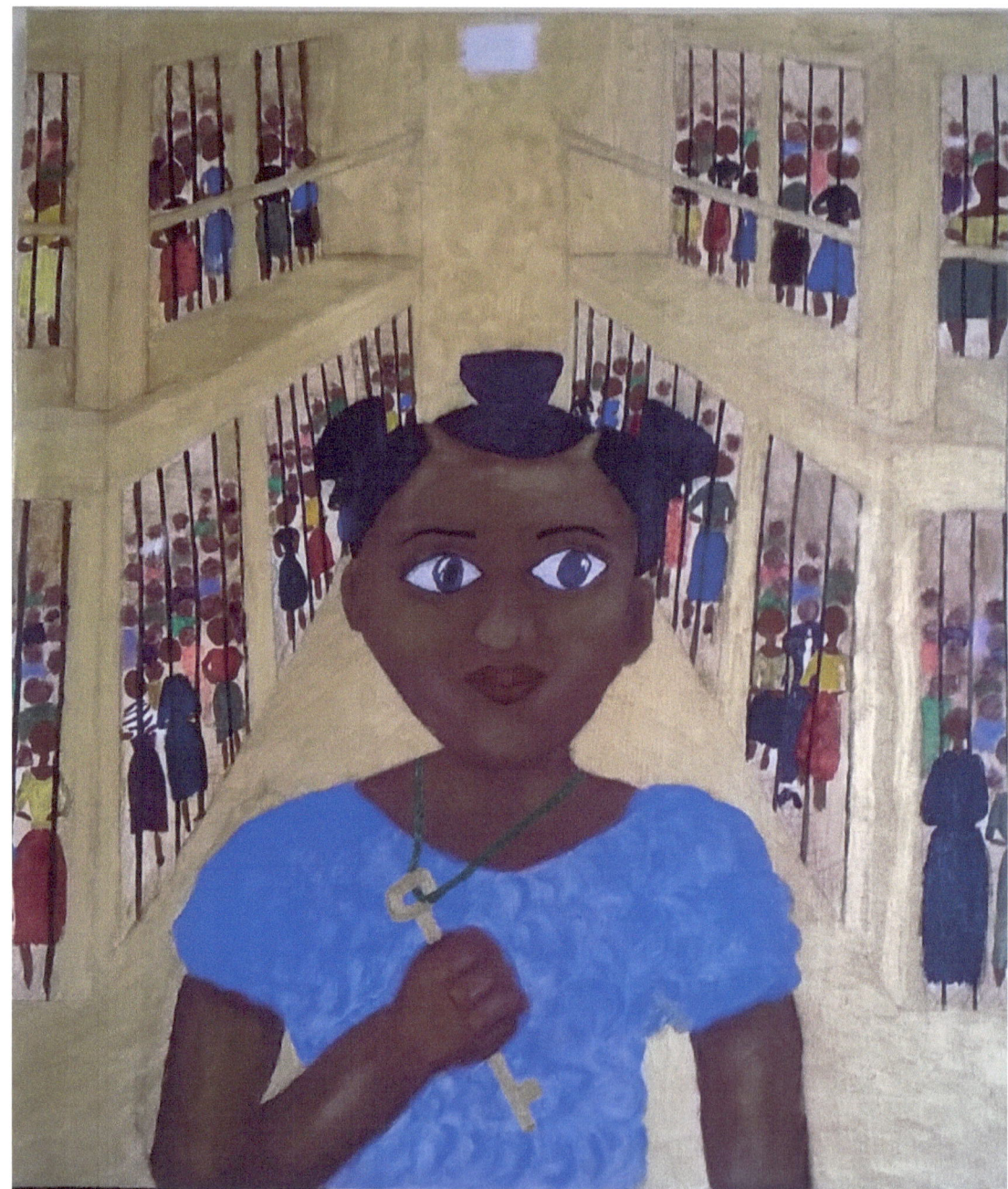

The Girl with a Key - Society

Oil on Canvas. 2018

The meaning behind this painting has been left at the discretion of the audience.

BODIES OF ART

1. The girl with a key. Oil on Canvas, 2010
2. The African runway. Oil on canvas, 2010
3. When enough is finally ENOUGH. Oil on canvas, 2010
4. If mother saw me now. Oil on canvas, 2010
5. Mouth of a Woman. Oil on canvas, 2010
6. The Drive. Oil on canvas, 2010
7. Her ring. Oil & beads on canvas, 2010
8. The wedding. Oil & beads on canvas, 2010
9. The Recording Forgiver. Pencil on cnvas, 2010
10. Sight cometh nigh. Oil on board, 2010
11. Pink Guernica. Pencil on canvas, 2010

Bonus Artwork :
The Girl with a Key - Society

RESPONSE

This segment contains a cross-section of comments from the audience:

—Fascinating! I can't believe it. So refreshing and challenging. Please take it on to the future!
Prof. Chris Kamlongera.(Principal of University of Malawi, Chancellor College, 2010)

—Can't believe Malawi has strong women with great talent like this
Vincent Maluwa (Artist)

—At times the grimness jumps at you as the only brightness is in the woman's eyes and the contents of goodies she carries…Yet the monty python- horror- of Pink Guernica is just so revealing about a woman's life. But what of the woman's mouth that's so venomous but guides lives; not to mention the celebration of feminity in 'full legs' and growing up in 'If mama saw me now'. Brilliant work. You have a future.
Prof. Mufunanji Magalasi (Drama Proffessor. University of Malawi, Chancellor College)

—Amazing. The exhibition captures the beauty and poetry but also the struggle and pain of life. Well done, Vera. We are proud of your achievements so far.
Prof. Kings Phiri (History Proffessor. University of Malawi, Chancellor College)

—Wow, very interesting and reflecting Malawi culture!! Good luck.
Andrew de Vergara (Medical Doctor. United Nations).

—Good work. Original and insightful.
Franz Amin (Lecturer in Philosophy. University of Malawi, Chancellor College)

—A very creative concept.
Okey Onah (Medical Doctor. United Nations)

—Art at its best.
Kumbukani Siska (Patroniser)

—You show us where the hope is... and the gratitude.
Dr Peter Stephany (Germany)

—These are not just paintings, there's a true story behind them.
Marah Mankhomwa (Patroniser)

—Excellent! Worthy for outside academic mounting. Keep it up!
Dr Chanunkha (Head of Fine and Performing Arts Department. University of Malawi, Chancellor College)

—...really thought stimulating. Really makes me appreciate the roles of women in a society.
Kanozga Moyo

—Weird.
 (Unnamed patron)

REFERENCES

Alice Walker(1983). In Search of our Mother's Garden: Womanist Prose. A Harvest Book, Harcourt Inc.
Buchi Emecheta(1979). The Joys of Motherhood: A Novel. Allison & Busby
John C. Maxwell. 2006. The Difference Maker. Nelson Business. USA.
Oxford Advanced Learner's Dictionary 7th ed. Oxford University press. UK
Gijs Van Hensbergen. 2004. Guernica: The Biography of a Twentieth Century Icon. Bloomsbury. US
Donve Lee. 2006. Dumile Feni: Making Art out Suffering. Awareness Publishing Group. South Africa.
Rosalind Omiston. (2014) 50 Art Movements You Should Know: From Impressionism to Performance Art. Prestel.
http://www.pablopicasso.org/guernica.jsp
https://study.com/academy/lesson/id-ego-and-superego.html

www.ingramcontent.com/pod-product-compliance
Lightning Source LLC
Chambersburg PA
CBHW041316180526
45172CB00004B/1119